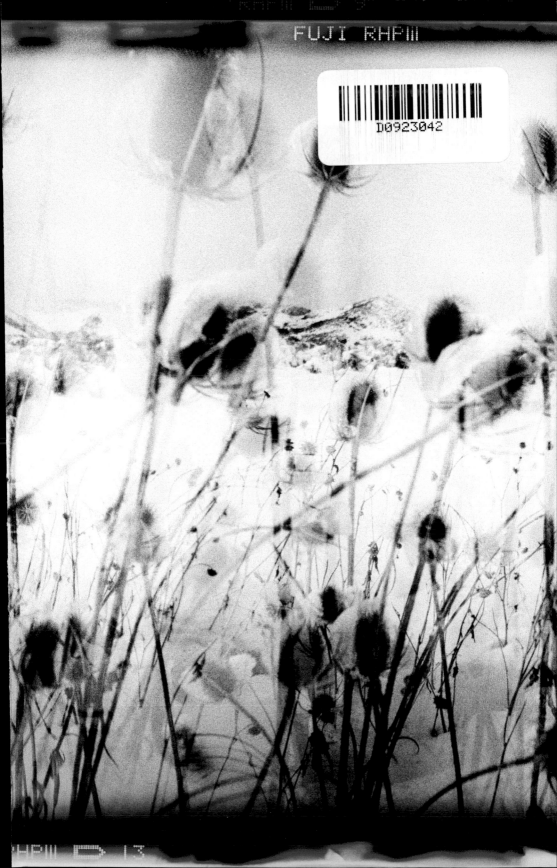

SKIP
David Newsom

ISBN 0-9774869-1-5
© 2005, 2009 Perceval Press
© 2005 All images David Newsom
Second Edition

Perceval Press
1223 Wilshire Blvd., Suite F
Santa Monica, CA 90403
www.percevalpress.com

Editor: Viggo Mortensen
Associate Editor: Walter Mortensen
Design: Michele Perez
Copy Editor: Sherri Schottlaender
Digital Print Mastering: Hugh Milstein, Digital Fusion

Printed in Spain at Jomagar S/A

Cover image: *Christmas*, 2004
Endpapers: *The Short History of Malad*, 2004
Back cover: *A/Drift*, 2005

SKIP

PHOTOGRAPHS BY DAVID NEWSOM

PERCEVAL PRESS

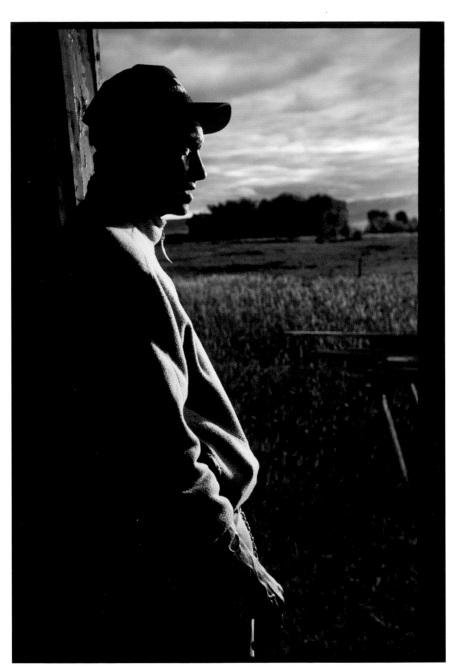

October, 2004

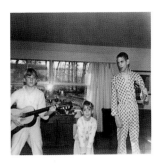

Jimmy, Me, Skip, 1967

In 1971, right after our dad moved out and our family started falling apart, my oldest brother "Skip" came home to live. I was nine, he was nearly twenty-three, and he'd always been a stranger to me, someone we picked up on holidays and treated like a guest. Skip was sweet, gangly, and had an odd, ecstatic way about him. As a young kid, I used to steal Christmas gifts and Easter candy from him, amazed that someone so old could be so gullible. My friends and I would follow him around the house and watch him from a distance, as if a rare bird was wandering the hallways of our New Jersey ranch house.

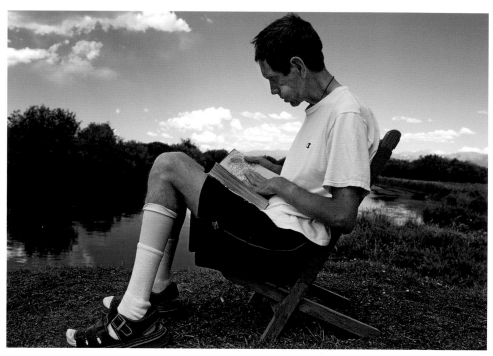

Picnic in the New World, 2001

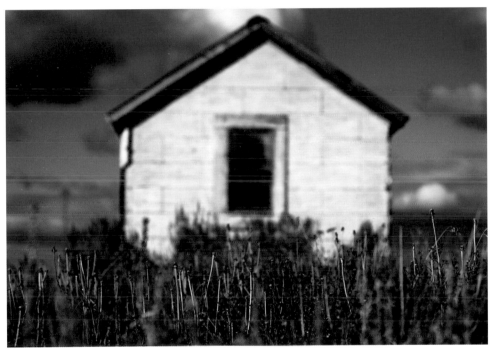

Little Shack, 2002

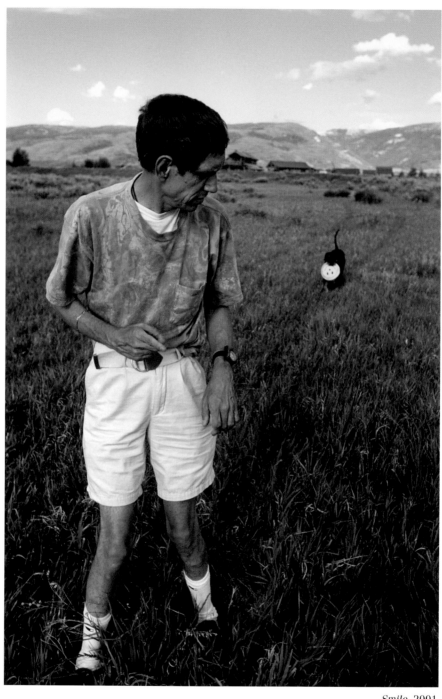

Smile, 2001

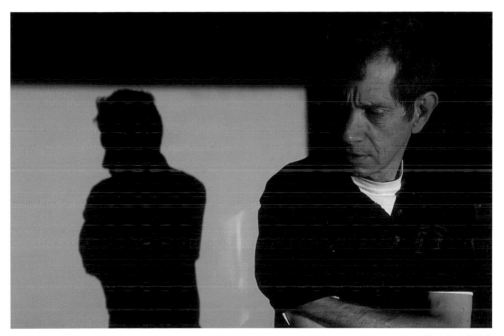

Untitled, 2003

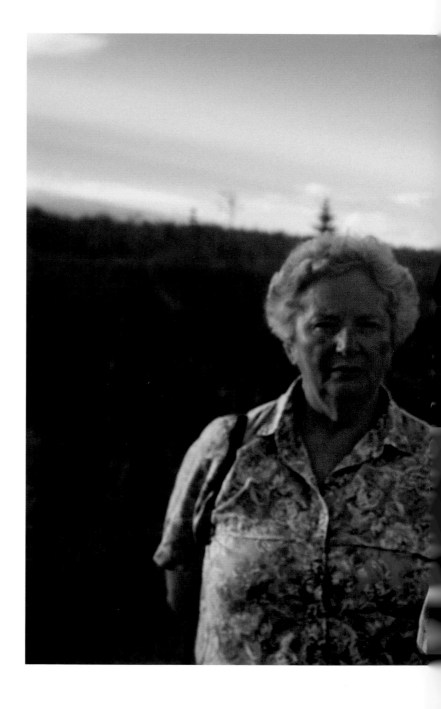

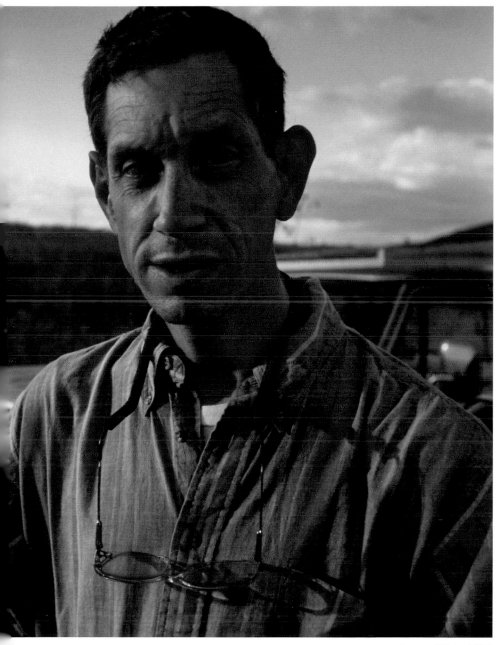

Joan and Skip, 1994

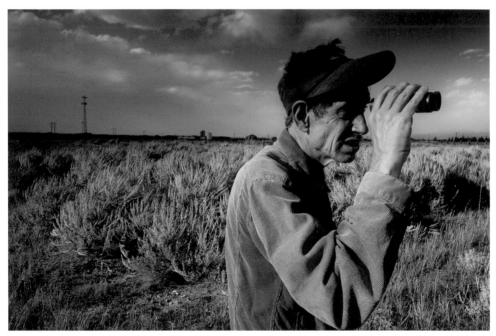

Untitled, 2004

His real name is Lloyd Curtis Newsom Jr. He was born with a learning disability that made him "The Skipper" of his own ship. That's how my parents saw it back in 1948, fresh from the war, struggling to keep their sense of humor. Excitable and prone to grab or push, Skip more than once placed his baby sister in the doctor's office, so he was moved to a state facility in south Jersey. We visited him weekends and holidays, a long drive down the interstate, picking up the narrow two-lane roads through the pine barrens to the institution. The facility seemed to stand in secrecy, staged deep in the pine trees, past dozens of tiny, coffee-colored streams. My father always locked us in the car when he went to get Skip. Other patients would come out to say "hi" and encircle the car. We were just kids, and the sight of them crowding the windows to see inside filled us with a kind of terrified delight. My dad would shoo them away as he loaded Skip and his bags into the station wagon, and we would laugh and wave good-bye.

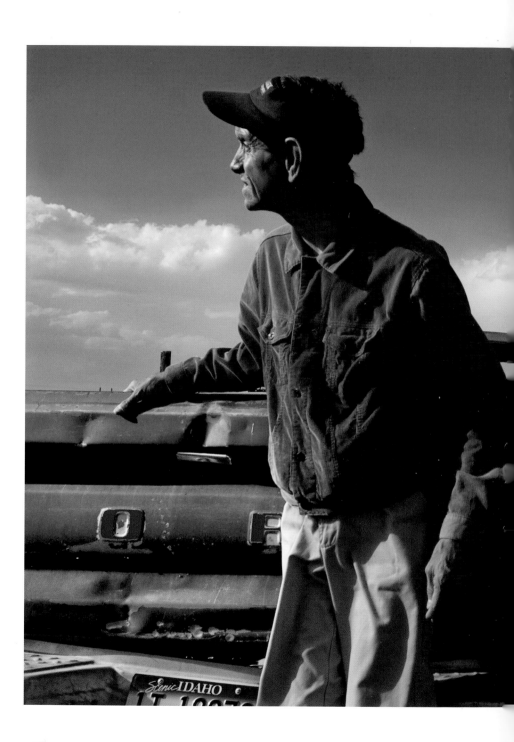

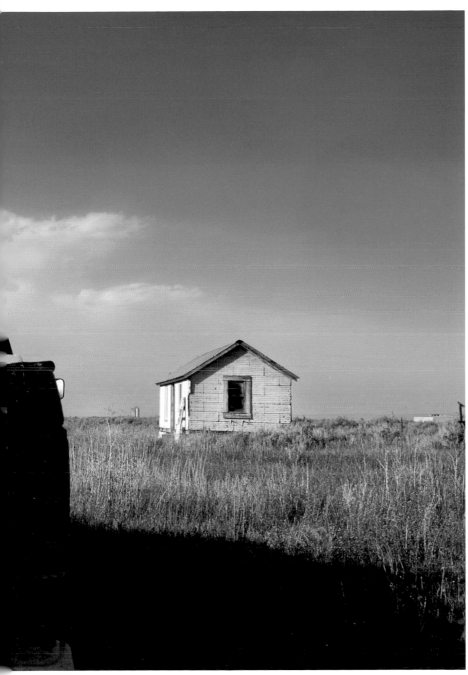

Shotgun, 2004

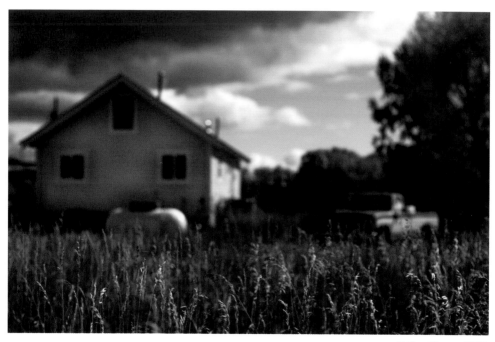

Yellow House, 2002

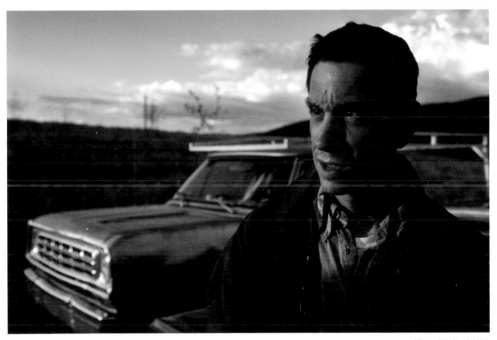

First Visit, 1994

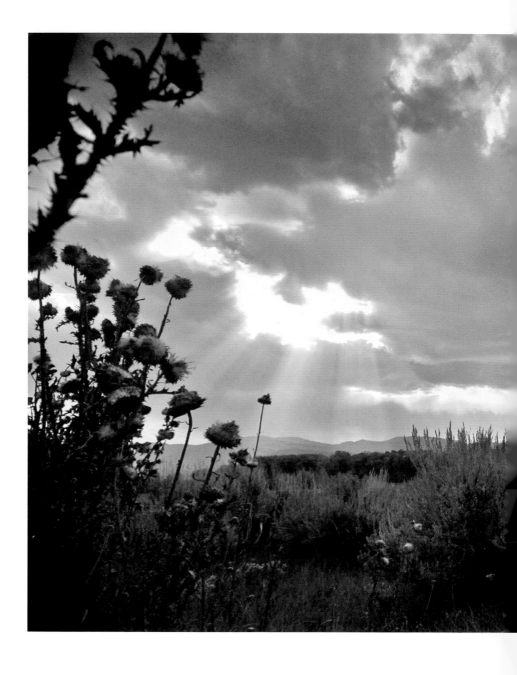

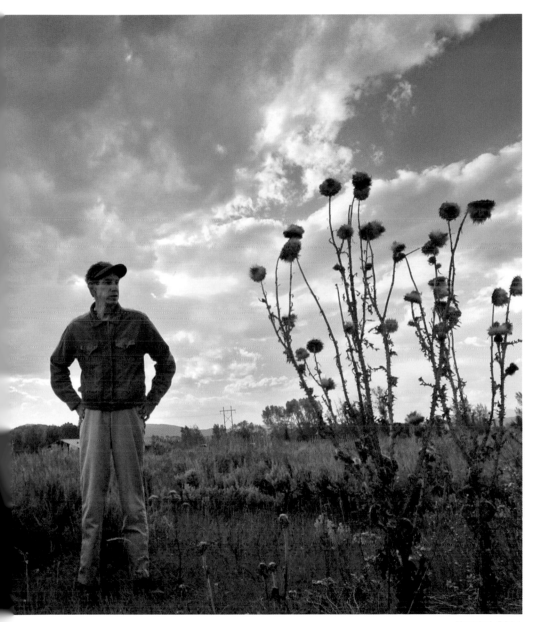

Untitled, 2004

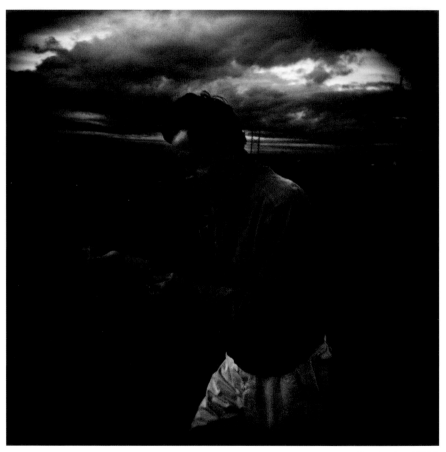

New Jacket, 2004

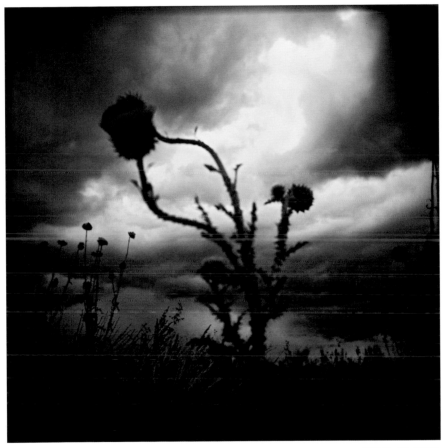

Thistle #1, 2004

Skip lived there for seventeen years. The relocation of their firstborn to an institution created a painful and often guilt-inducing absence for my parents, made worse only by a growing sense that life in the institution was miserable. Though Skip never really had an unkind word for anyone, over time clues to his unhappiness appeared—a laundry list of small abuses and neglect that made themselves known in the form of illnesses, distrust, and fears that made it hard to justify his being there. His private memories rattle him to this day. He still keeps nearly all he owns in his pockets—a Bible, the broken flashlight, his flash-cards, some breath spray, an old bottle of cologne, his ball cap—the nervous habit of a boy protecting what's his. To this day the nightly ritual of getting Skip ready for bed includes a long, comedic emptying of pockets, like a magician pulling countless rabbits from a hat.

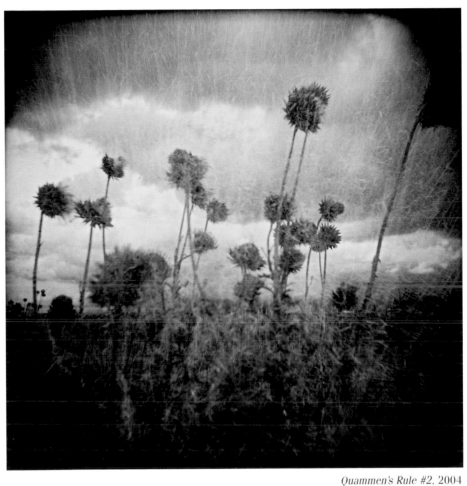

Quammen's Rule #2, 2004

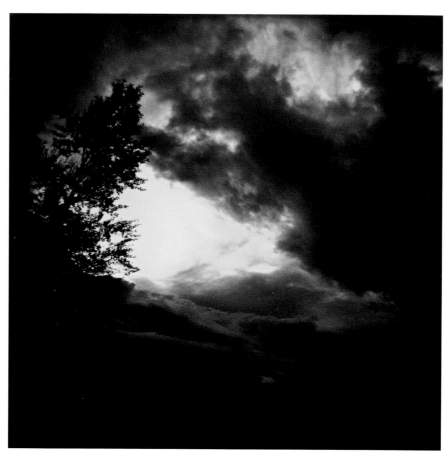

Walking with Lloyd, 2004

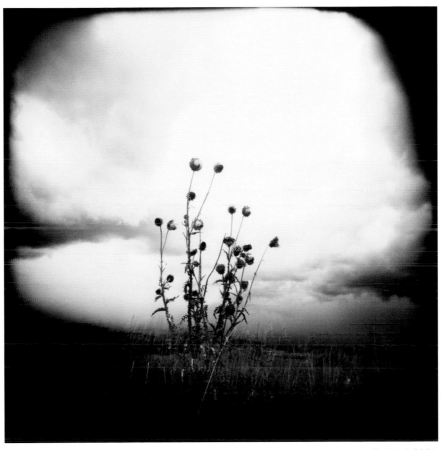

Untitled, 2004

Finally the day came when he returned home. My mom showed him to his new room, right off the front hall, where he instantly unpacked. Minutes later I found him standing at his window, his thin profile motionless, fingers nervously flipping through his Bible. "I'm not going back there," he said solemnly.

Over time, all the kids moved on to wander the country, each one rootless, exploring odd jobs, moving farther and farther away from New Jersey. Skip, on the other hand, stayed and was moved to other state-run "assisted living" facilities where mom and dad could both visit him. Mom died of a stroke in early 2000. By some miracle, we were all there at her bedside when she passed. At the memorial service, Skip wore her big-brimmed straw hat and sashayed around asking, "How do I look?" and "Where's Mom now?" Jeffrey told him, "Heaven." He took it pretty well, then asked, "When's she coming back?"

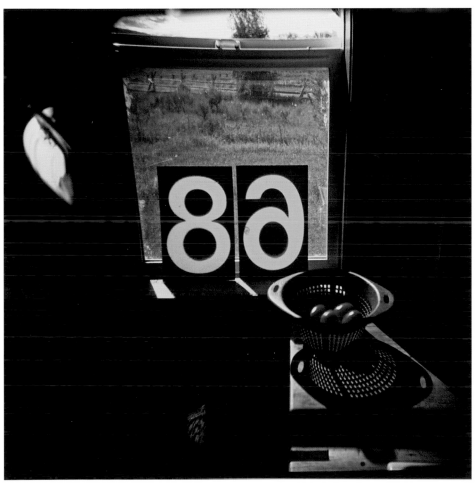

68 West, 300 South, 2004

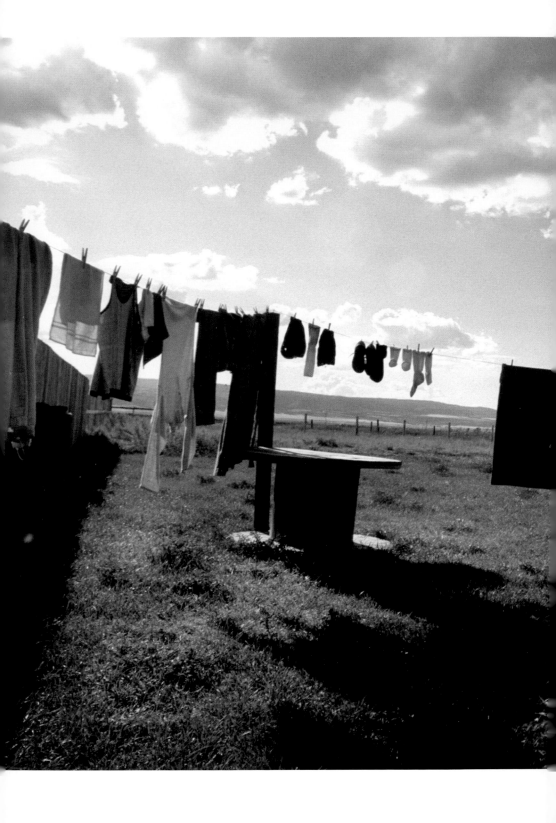

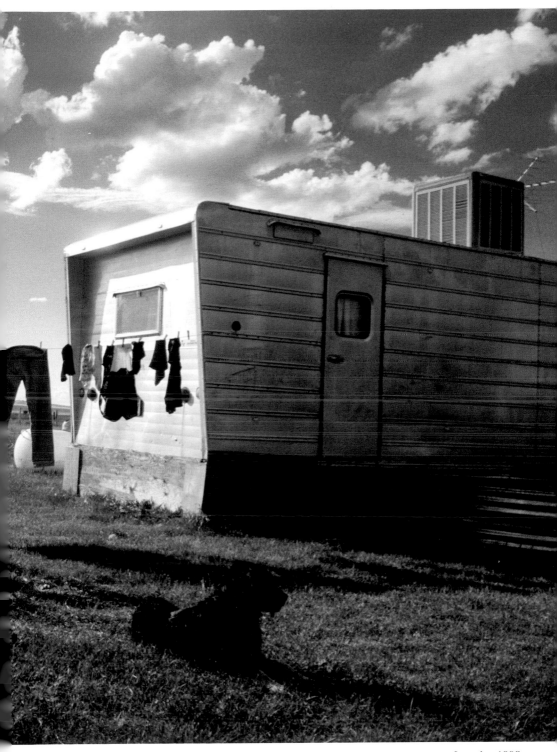

Laundry, 1998

My brother Jeffrey landed in the Teton Valley in 1986. My sister came out to visit in the mid nineties and eventually bought thirteen acres across the street from him. It's altogether an unlikely kingdom, eighteen acres of sage and cottonwoods not far from the highway. Skip came to visit the Teton Valley with my mom for the first time in 1994. He seemed pretty happy there. Maybe he liked what all Easterners like on their first visit west—the infinite sky and open, rolling landscape butted by three mountain ranges. He wandered up and down the gravel driveway of Jeffrey's place, exclaiming "Oh, boy!" with his arms stretched wide like a mating crane. I have a picture of my mom, standing where he stood on the first visit, imitating him under a big rainbow. After my mother's death Jeff and Ginny decided to move Skipper out to be near them, and finding him a group home in the Teton Valley. He'd never lived out of an urban area, never lived out of New Jersey.

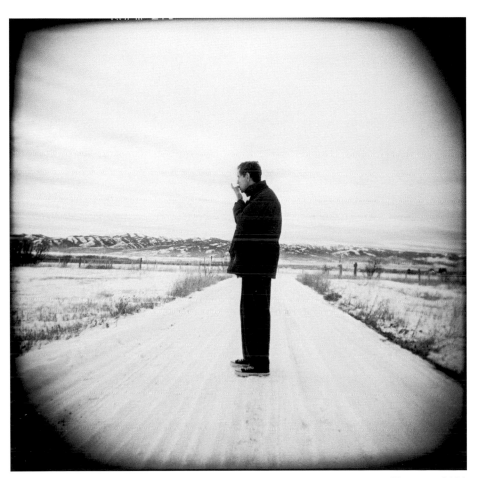

Christmas, 2004

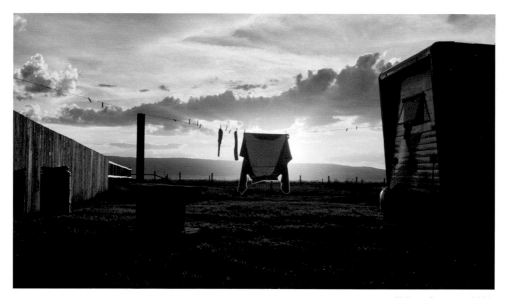

Yellow Sweater, 1997

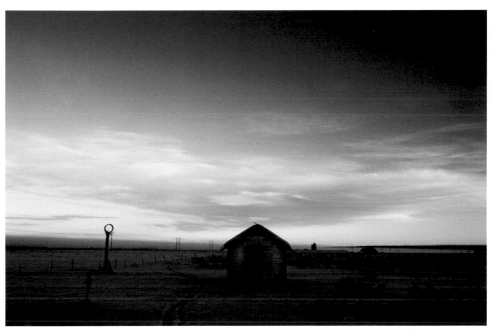

10 Below 0, 2001

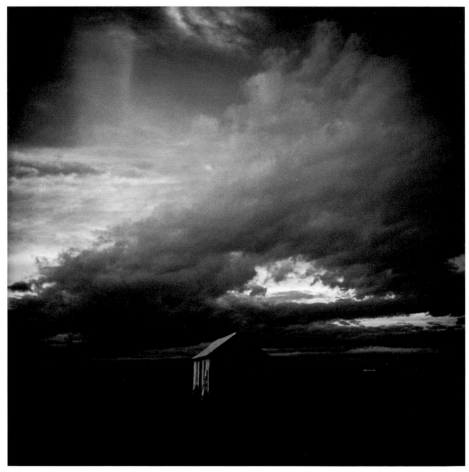

Untitled, 2004

Skip has been there for four years. On July 27th, 2005, my sister wrote:

"Being in Idaho has served Skip well. . . . wandering town on his own scared the hell out of me at first, but my fears were misguided. He's the mayor around here. I am in fact no longer me but have become 'Skip's little sister,' just like when we were kids. He's coming along. . . . He can be trusted to take the dogs for a walk around the thirteen acres without any of them disappearing. Now if he could just learn to brush his own teeth before he turns sixty."

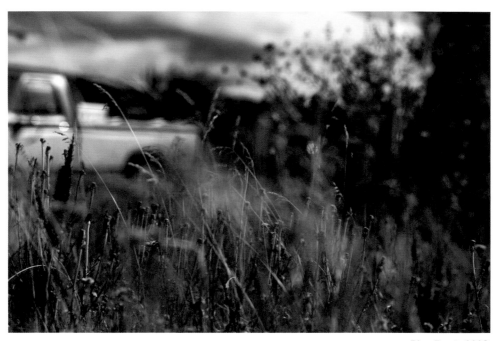

Blue Truck, 2002

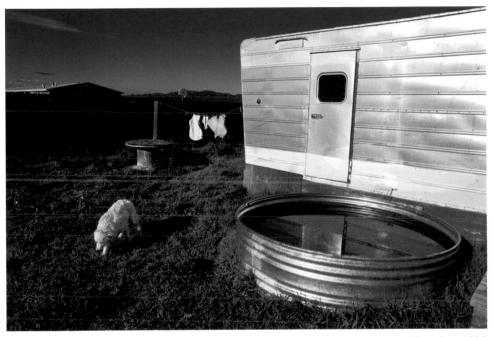

White Dog, 1998

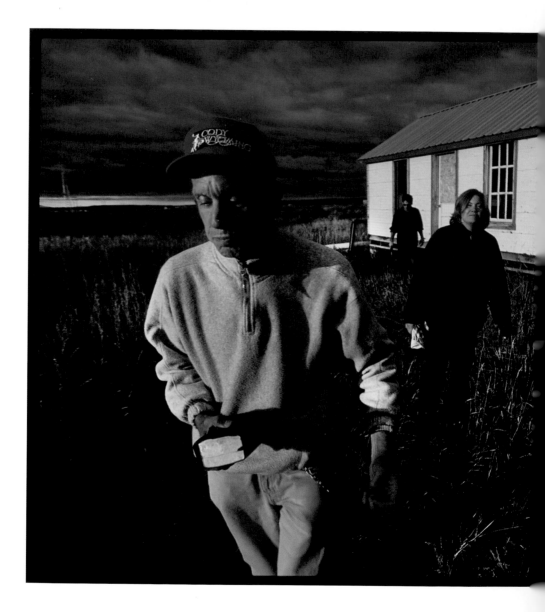

He always carries his Bible. He once looked at the cross at the top of telephone poles and said enthusiastically, "That's where Jesus lives!"

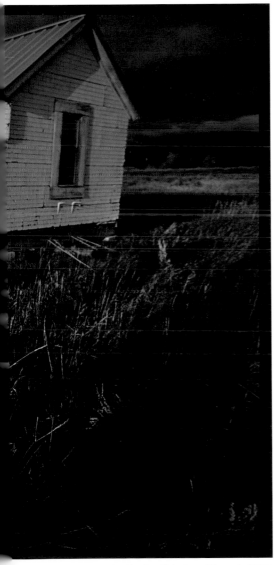

Exodus (Mexican Dinner), 2002

Recently, on a walk with Skip through my sister's field, I stopped beside a large colony of thistle, the spine-covered, invasive pest overtaking much of the West. In the Teton Valley orders stand to kill it on sight, so unwelcome is its presence. However, it possesses a bright fuchsia bloom, dramatic and distracting, atop its lethal stem. Skip, the four mutts, this much-vilified plant, and myself stood around in silence as I considered terminating the tough invader with an old rake handle. I came around to taking pictures of it instead. Skip stood by in his "new" thrift-store corduroy jacket, his pockets stuffed, as ever, to distortion, and shouted after the dogs, who were headed for the neighbor's horses. They wheeled around, fell in at his feet, and I watched him shepherd them back toward Ginny's little yellow house.

"Where are you going?" I shouted.

"We're late for dinner," he shouted back over his shoulder.

I pocketed my camera and followed Skip and the dogs, leaving the thistle to live another day. None of us—strays, transplants, or weeds—really belongs there, but some, at least, have found a home.

—DAVID NEWSOM
 OCTOBER 17, 2005

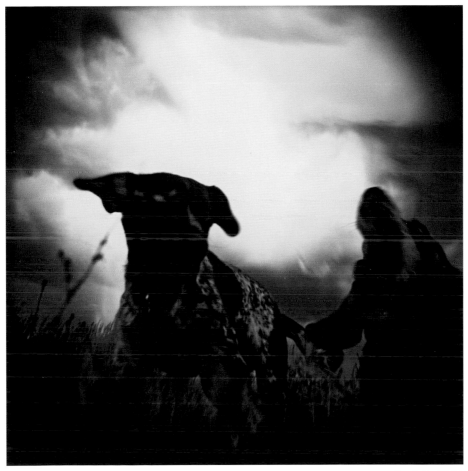

Dogfight, 2004

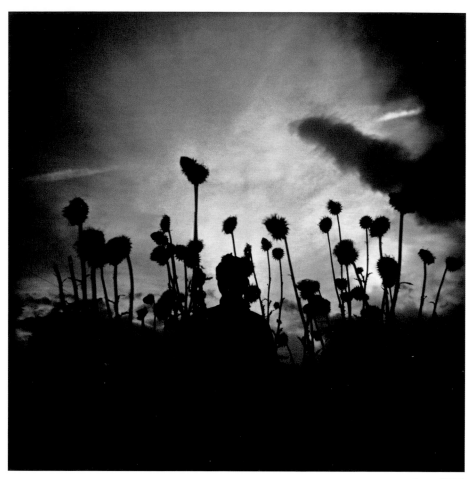

Late, 2004

ACKNOWLEDGEMENTS

This book lives strictly due to the kindness and generosity of
Viggo Mortensen, Hugh Milstein, and the very good folks over at
Perceval Press. It's hard to fathom the synchronicity that inspired
Mr. Mortensen to encourage a book of images I had secretly envisioned
for years, but so it was, and here it is: a collaboration between subjects,
photographer, printmaker, and publisher that makes that private
inkling manifest. Its creation has been a pure joy.

I would also like to thank my brothers, Jeffrey and Skip, and my sister
Ginny for their patience, love, and perseverance on the road less traveled.
These images are proof positive that they were and remain my heroes.

Thanks, Ski, for the assist, and Idaho, for your endless beauty,
contradictions, and extremes in weather.

For Mom, whose work I steal from more than I mean to; Dad, who taught
me to persist; Jagadish, who returned to the circle in 2000 and stayed;
and Siân, who knows wheat from chaff and says so.

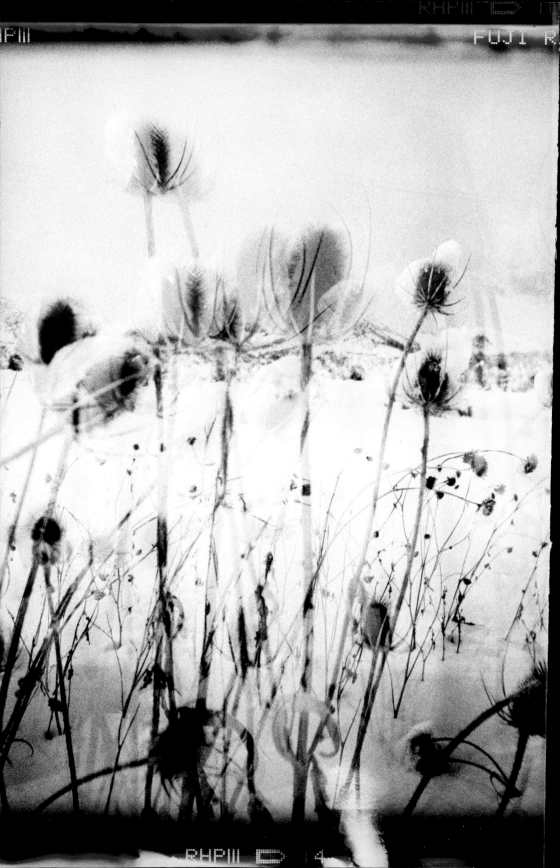